House Sitting

Published by Angela Ward and Wendy Bramall

Words ©2021 Angela Ward
Pictures ©2021 Wendy Bramall
The moral right of the authors has been asserted.

A catalogue record for this book is available from the British Library.

ISBN 978-1-8382577-8-1

Designed by Tim Underwood timund@hotmail.com
Printed by Sarsen Press 22 Hyde Street, Winchester, SO23 7DR

Tribute

"My admiration for Mary Keer began before arriving to her home, and finally meeting her. I was fortunate to get to know her world through weaving. Her world was full of details, organization, and sensibility. I found light, colour, textures, and natural patterns everywhere. Mary had an overflowing generosity and overwhelming humility, a natural smile, and a spontaneous, peaceful joy. This is my tribute to the legacy of Master Mary Keer, for her passion, commitment, energy, and vitality. Her infinite patience resounds like a fertile and permanent voice in my soul."

Maximo Laura – Master Tapestry Weaver

Maximo Laura is a Master Weaver. The Peruvian Government declared him a National Treasure and their Cultural Ambassador. He is recognised as one of South America's pre-eminent textile artists. Laura is known for tapestries that intertwine Peruvian tradition with contemporary aesthetics. Owners of Laura's work include the World Bank in Washington D.C., the UNESCO Headquarters in Paris and the Smithsonian's National Museum of the American Indian – to name but a few.

maximolaura.com

Introduction

This little book began its journey, over twenty years ago, when Angela and her husband, Andy, rented land next to Kipping Cottage – the former home of Mary Keer. They planned to build a plant nursery. Mary was extremely supportive of their venture. She would appear with sandwiches, cakes, and tea to replenish them after long days at plant fairs. In return Angela and Andy lugged looms from house to workshop and back again. Their friendship grew strong.

Mary suggested the couple might like to house-sit when she was away on her travels: they would be nearer the nursery; Mary would know her home was being cared for. The first poem was written in those early years. It was for fun and to make Mary smile. Then it was put away and forgotten about.

When Mary taught weaving, the Nursery car park was used as an overspill. The weavers would arrive, laden with looms and plates of food to share. It was a wonderful sight: a community of creative women enjoying one another's company. Wendy was one of those women. She would often stop and chat with Angela. Yet another friendship began to blossom.

For Mary's ninetieth birthday she organised nine separate parties. She wanted to thank all her wonderful weavers, friends, and neighbours. She insisted that there be no presents. However...

Pondering presents, over a cup of tea, Angela showed Wendy the little poem about house-sitting for Mary. Their first idea was a card. Wendy would illustrate the cottage and Angela's poem would be on the back. The momentum grew. Before they knew it, they had decided upon a book. With holidays looming, they needed to get moving. They only had a few weeks to finish the project.

Mary was away the following week and Angela would be house-sitting. Wendy came to visit. They took photos of all the things they loved about the cottage and garden. On Mary's return, Angela took a photograph of her working the large loom. Wendy bought a book. Now they had all they needed to start their project.

With Angela going on holiday, everything needed to be organised via email. Poems and paintings whizzed back and forth between Winchester and Cornwall. On Angela's return, Wendy presented her with the book of illustrations: it was beautiful. Angela now had to handwrite the poems and not make any mistakes. It was a daunting task. She made one! Wendy forgave her.

Mary said that this little book was the best present she had ever received. It brought her joy and comfort. Now, wherever she travelled, she could take her home with her. This summer Mary decided that she would like to share this book with you.

This book is dedicated to Roxana and Sally –
our extremely beautiful, talented and creative daughters
and to all those who keep traditional skills alive.

House
Sitting

When house-sitting for Mary Keer
there's things you should beware!
Not big things, just small things
that catch you unawares

Like the spider in your dressing gown,
the startled moth within a drawer,
or the armour-plated battalion
that patrol the bathroom floor.

There are red ants in the compost heap
that will ravage your big toe,
And vespula dive-bombers
make areas of no go!

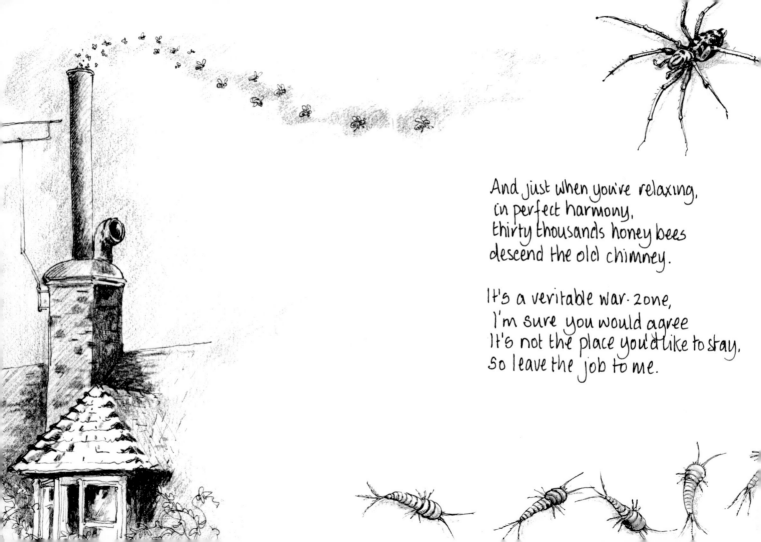

And just when you're relaxing,
in perfect harmony,
thirty thousands honey bees
descend the old chimney.

It's a veritable war-zone,
I'm sure you would agree
It's not the place you'd like to stay,
so leave the job to me.

Oh Dear!

What a to-do.

I haven't really been honest with you.

Take a look

Inside this book

You will plainly see

It's just the place you'd like to stay

But please don't usurp me!

For I love to sit in the porch way
at dawn and again at dusk
Listening to the melodies
of the beautiful speckled thrush.

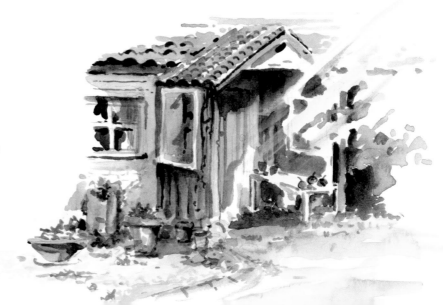

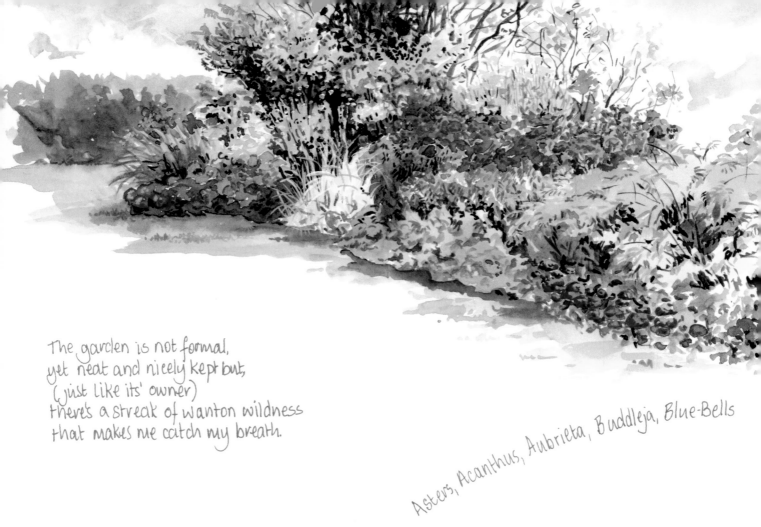

The garden is not formal,
yet neat and nicely kept but,
(just like its' owner)
there's a streak of wanton wildness
that makes me catch my breath.

Asters, Acanthus, Aubrieta, Buddleja, Blue-Bells

Festuca, Foxglove, Geranium, Galega, Galanthus

Cichorium, Crocus, Clematis, Daphne, Deschampsia

Erigeron, Erica,

Honesty,

Hellebore, Hedera

Iris, Jasmine, Knautia

Mint, Malva, Maple

Ox-eye Daisy, Omphaloides, Ophiopogon

Phlox, Paeonia, Perovskia, Prunus,

Lilac, Ligustrum, Lonicera,

Narcissus, Nigella

Queen Ann's Lace

Rudbeckia, Ranunculus, Ribes,

Nepeta

Ras...

Stipa, Sedum, Scabiosa,

Tulipa, Tellima, Tomatoes,

Umbels, Viola, Vinca,

Wisteria

XmasTree!, Yew

Zzzz

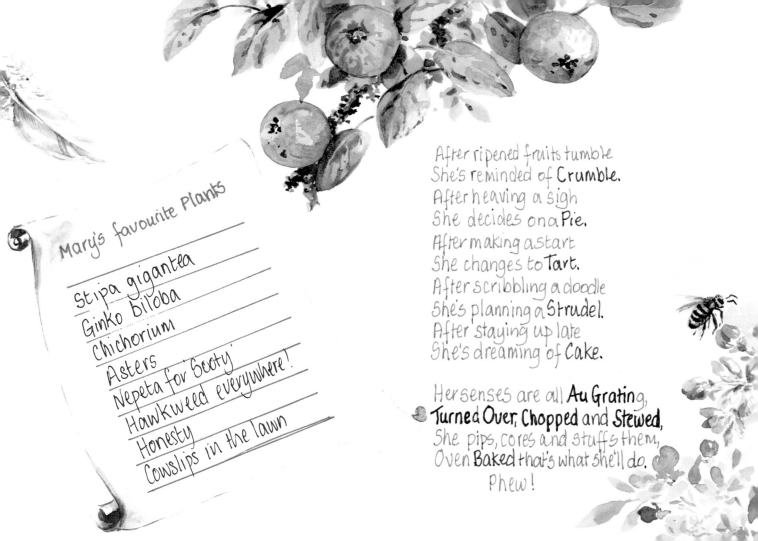

Mary's favourite Plants

Stipa gigantea
Ginko biloba
Chichorium
Asters
Nepeta for Booty
Hawkweed everywhere!
Honesty
Cowslips in the lawn

After ripened fruits tumble
She's reminded of **Crumble**.
After heaving a sigh
She decides on a **Pie**.
After making a start
She changes to **Tart**.
After scribbling a doodle
She's planning a **Strudel**.
After staying up late
She's dreaming of **Cake**.

Her senses are all **Au Grating**,
Turned Over, Chopped and **Stewed**,
She pips, cores and stuffs them,
Oven **Baked** that's what she'll do.
Phew!

CLASSIC APPLE CHUTNEY

Ingredients:

1½kg cooking apples, peeled and diced
750g light muscovado sugar
500g raisins
2 medium onions, finely chopped
2 tsp mustard seeds
2 tsp ground ginger
1 tsp salt.

Pop all ingredients into a large pan. Simmer 30 mins
Cool. Transfer to clean dry jars. Seal.

Saw you swaying in the wind
in sun-setting languished light.
Burnished, golden, glistening
you shimmied into shadowed night.
Your sparkling sheaves resplendent
silvered stipa, so tall, so elegant.

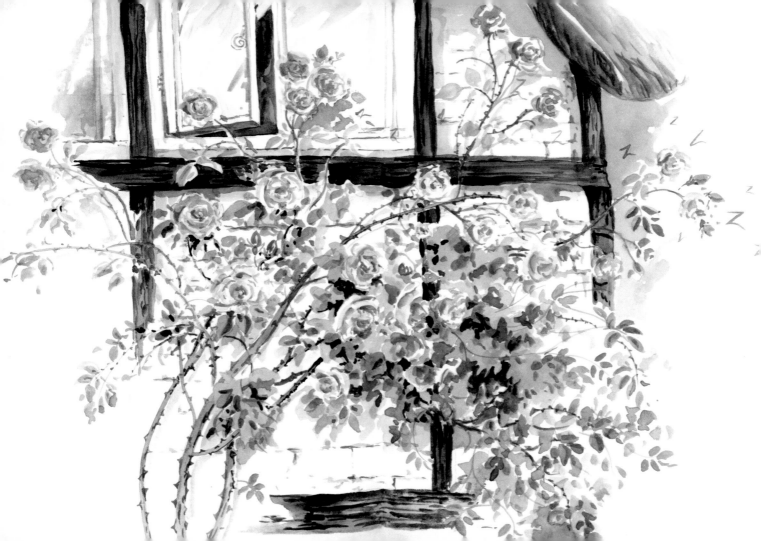

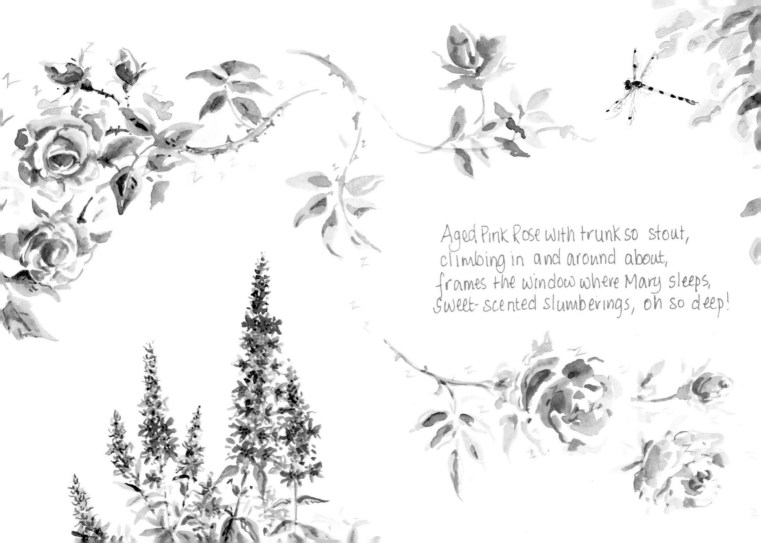

Aged Pink Rose with trunk so stout,
climbing in and around about,
frames the window where Mary sleeps,
sweet-scented slumberings, oh so deep!

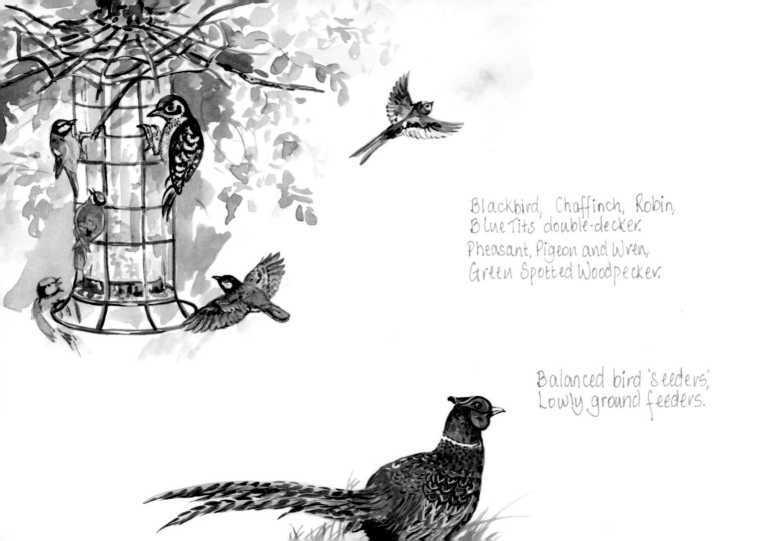

Blackbird, Chaffinch, Robin,
Blue Tits double-decker.
Pheasant, Pigeon and Wren,
Green Spotted Woodpecker.

Balanced bird 'seeders',
Lowly ground feeders.

Winding Wisteria weaves
 under and over the cottage eaves.
Peeping from its' lush green leaves
Perfumed hanging racemes.

Naughty Sooty sleeping,
Sweet Nepeta scheming,
Catching birds afeeding,
Sweet Nepeta dreaming.

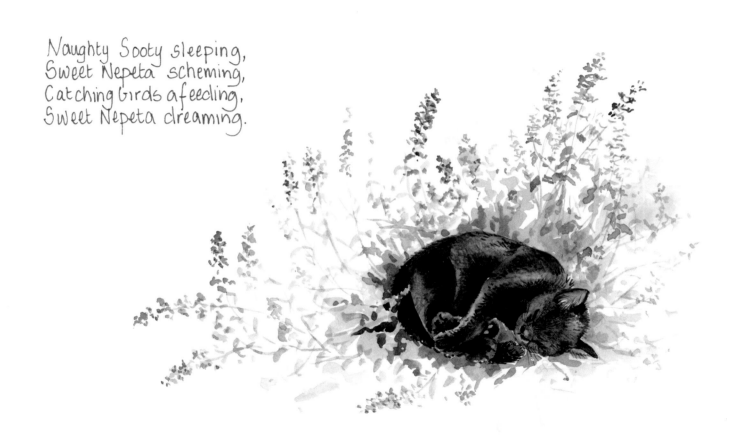

Ginkgo biloba

A Tree.
Not just any tree.
This tree holds our history
Locked in fossils,
Two million years old,
With secrets yet untold.
This tree, single species, solitary
Is a symbol of hope and longevity.
A rare, precious plant of palaces,
Mountain monastries, temple gardens.
And I wonder, did you know
Their nuts taste like Pistachios?
Revered pearls, presented, so I'm told,
To Emperors, in bowls of gold.

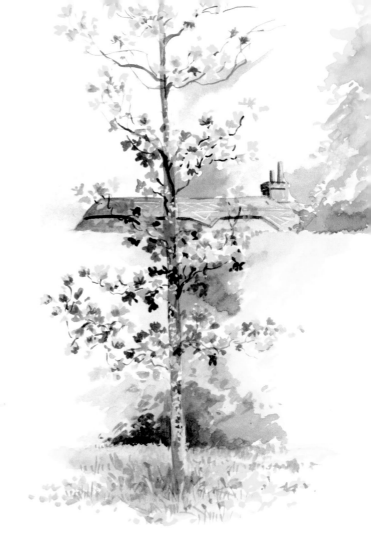

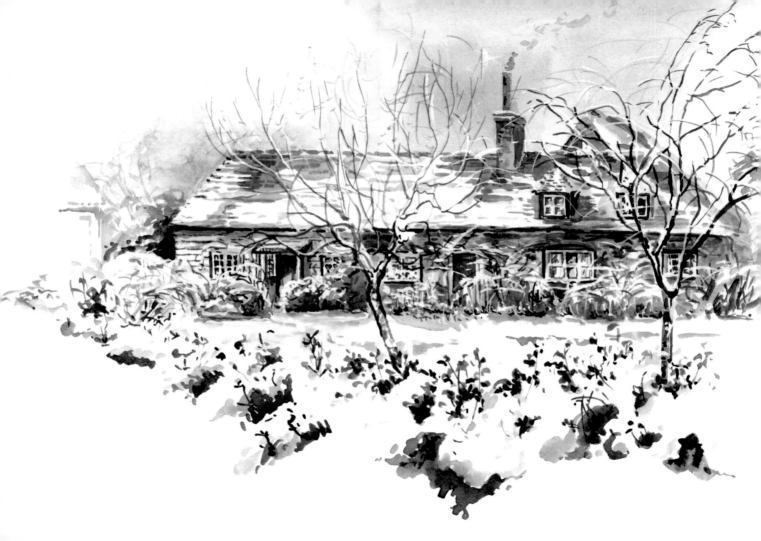

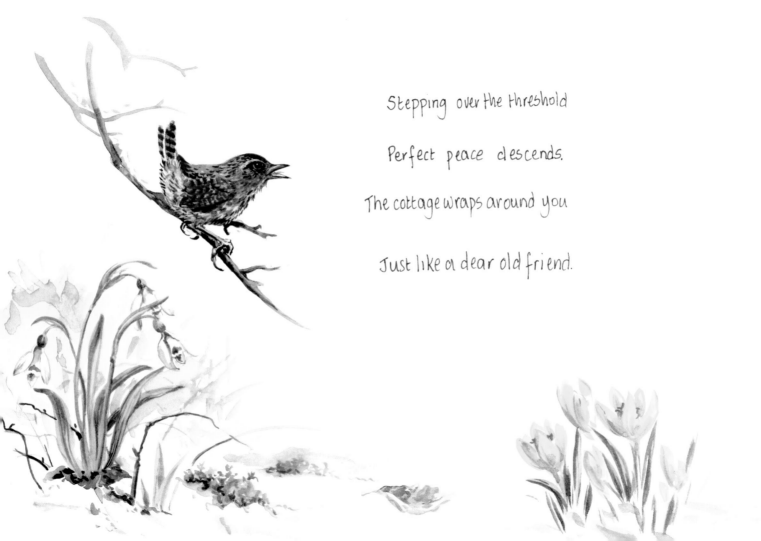

Stepping over the threshold

Perfect peace descends.

The cottage wraps around you

Just like a dear old friend.

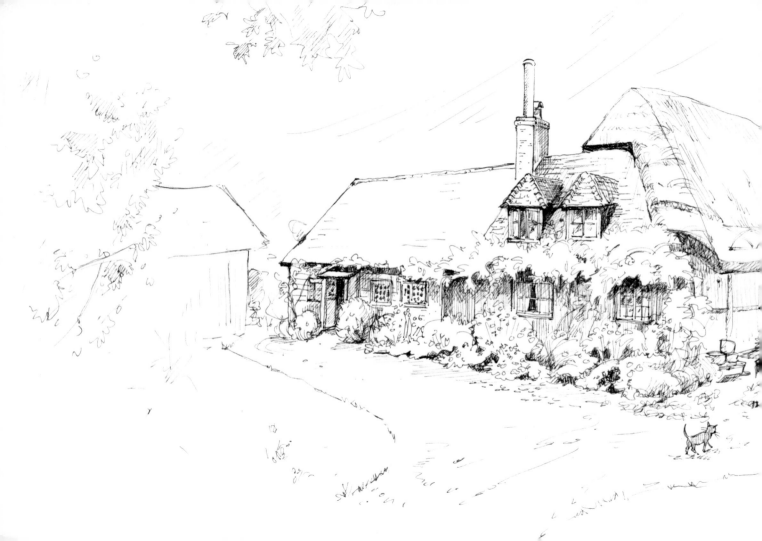

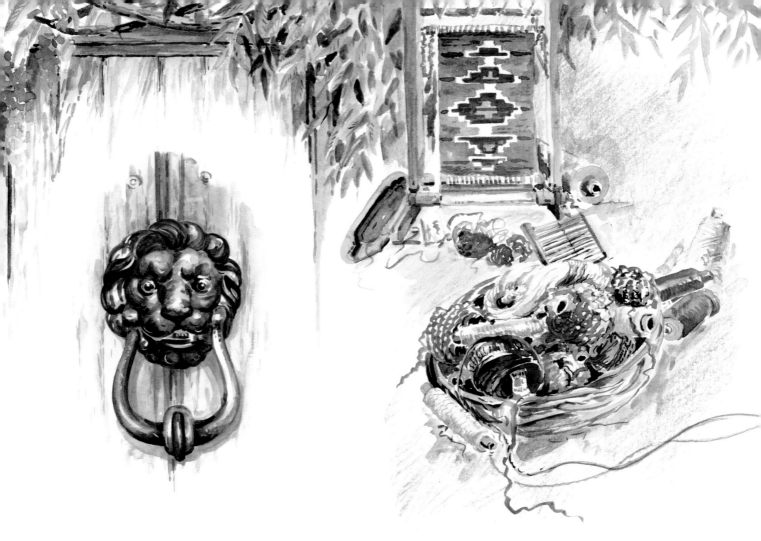

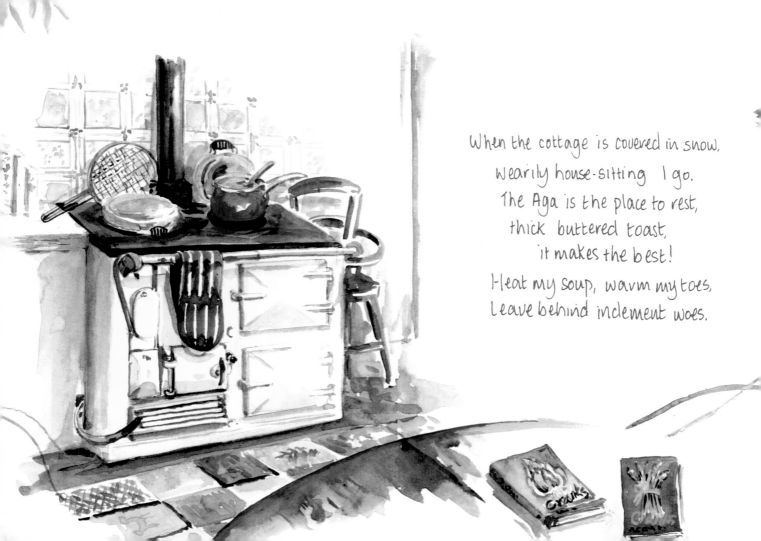

When the cottage is covered in snow,
wearily house-sitting I go.
The Aga is the place to rest,
thick buttered toast,
it makes the best!
Heat my soup, warm my toes,
Leave behind inclement woes.

Wander from room to room,
Wonder at artefacts prepared on looms.
Intricate sensual delights,
many brought back from far flung flights
where traditional families weave
patterns of treasured ancestry.

Sundays.
Climb the clock face.
Reach for the key.
Steady!
Crank the handle
Watch the pendulum rise
Tick. Tock.
Tick. Tock.
Tick. Tock.

A polite cough
before striking the hour.
Time passes. So slow.
No need to hurry
No rush to go.

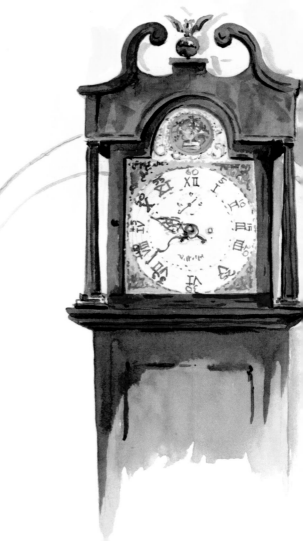

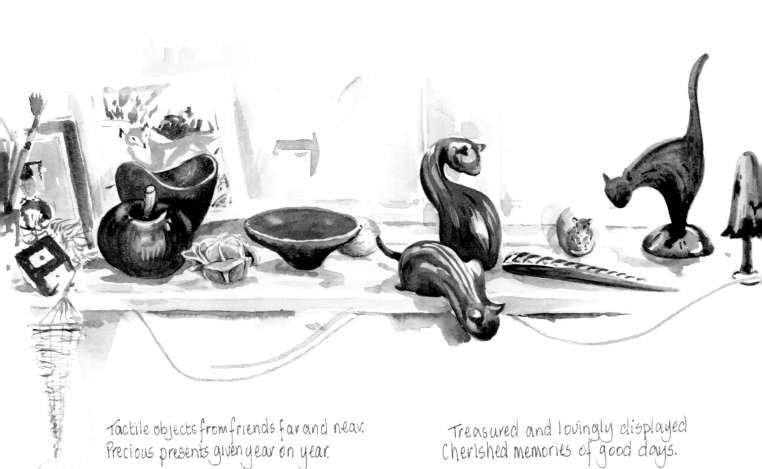

Tactile objects from friends far and near.
Precious presents given year on year.

Treasured and lovingly displayed
Cherished memories of good days.

Curtains cushions rugs,

ponchos, scarves, shrugs.

Polished bowls, wooden spoons,

carved cats, mushrooms.

hina cups, ornate vases,

pressed leaves and dried grasses.

Mongolian yurts, mah-jong box,

rainbow yarns for Christmas socks.

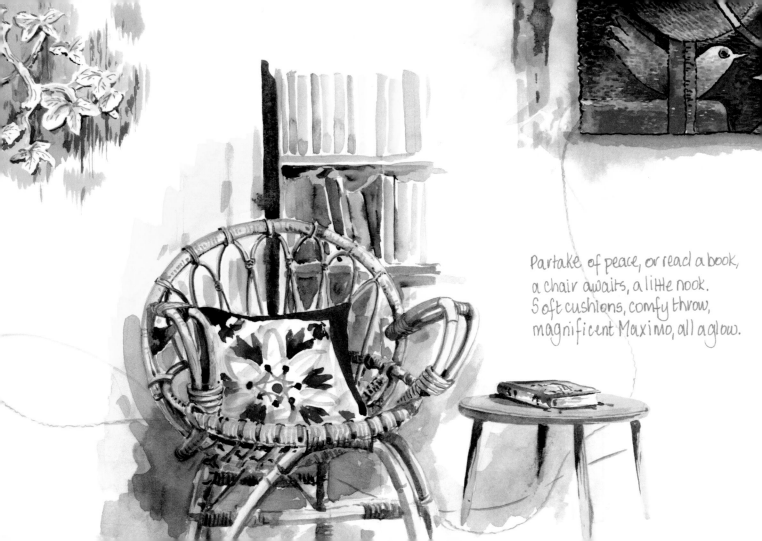

Partake of peace, or read a book,
a chair awaits, a little nook.
Soft cushions, comfy throw,
magnificent Maximo, all aglow.

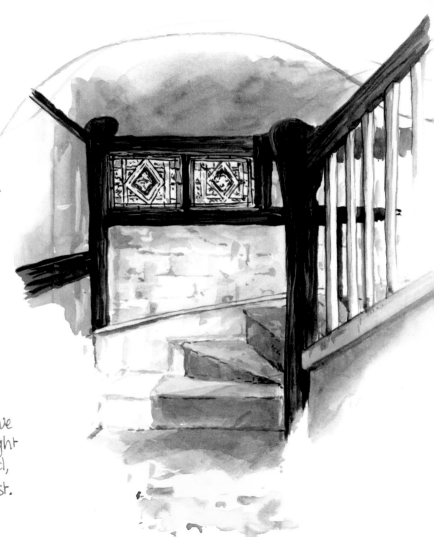

Two stained glass crowned jewels

dust dustered glittering hues.

Climbing the stairs,
place your hand where
a multitude of others have
grasped, gripped, held tight
to time-worn, moulded,
leaning warm wood post.

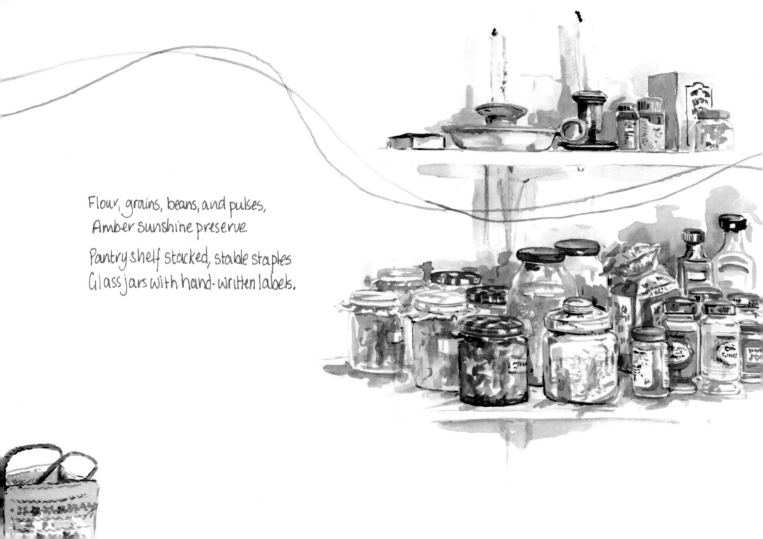

Flour, grains, beans, and pulses,
Amber sunshine preserve.

Pantry shelf stacked, stable staples
Glass jars with hand-written labels.

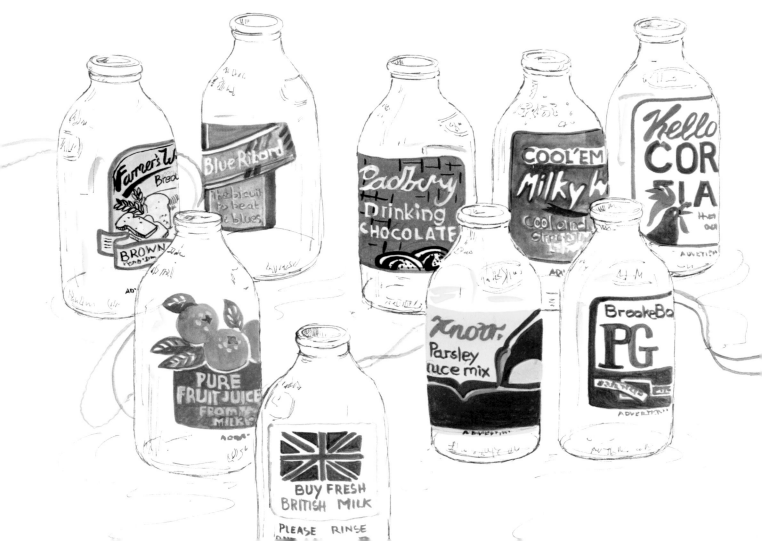

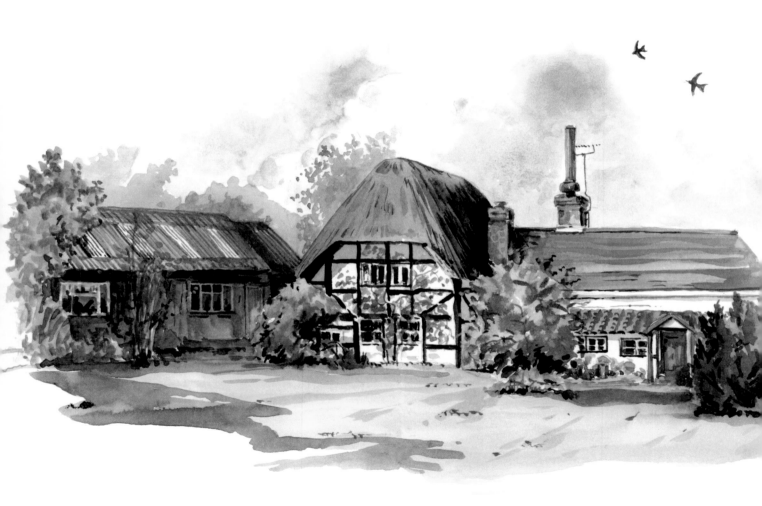

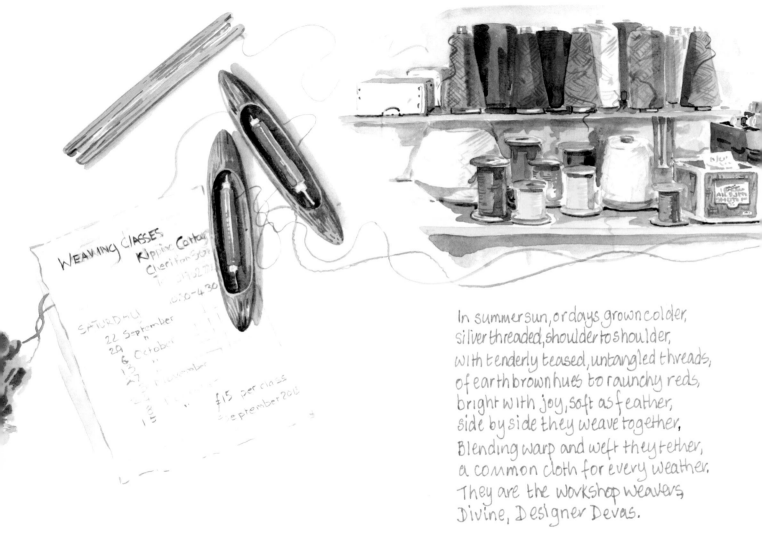

WEAVING CLASSES
Kippline Cottage
Cheriton Som...
T: 019627...
10:0 - 4.30

SATURDAY
22 September
29 "
6 October
13 "
...November
...
$15 per class
September 2012

In summer sun, or days grown colder,
silver threaded, shoulder to shoulder,
with tenderly teased, untangled threads,
of earth brown hues to raunchy reds,
bright with joy, soft as feather,
side by side they weave together,
Blending warp and weft they tether,
a common cloth for every weather.
They are the Workshop weavers
Divine, Designer Devas.

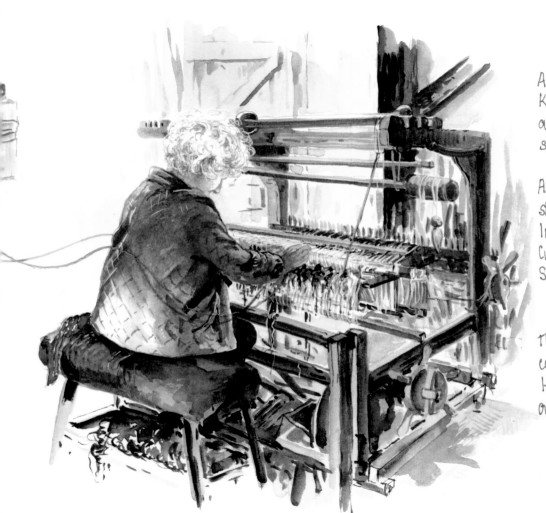

MARY

An idea came in the dead of night,
Kept her awake
and try as she might,
she could not shake it off.

As morning broke, sun overhead,
she sped to select her chosen threads,
In blue perhaps? No green instead.
Creative muddle in her head,
Shaping up to something
 beautiful.

The warp set first, a weft or two,
colours blend, in glorious hues.
Her foot sped, the shuttle flew,
a masterpiece comes into view.

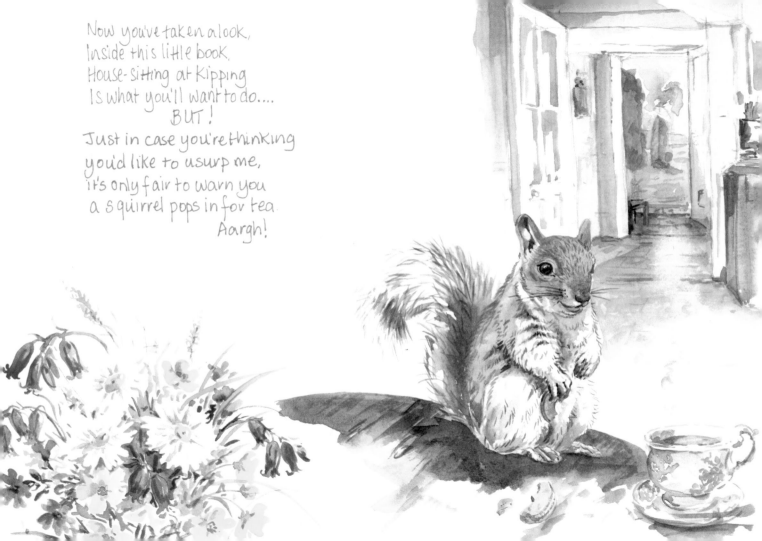

Now you've taken a look,
Inside this little book,
House-sitting at Kipping
Is what you'll want to do....
BUT!
Just in case you're thinking
you'd like to usurp me,
it's only fair to warn you
a squirrel pops in for tea.
Aargh!

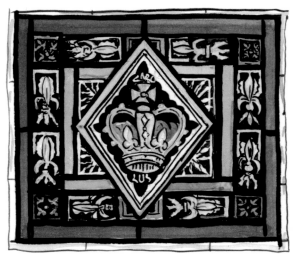 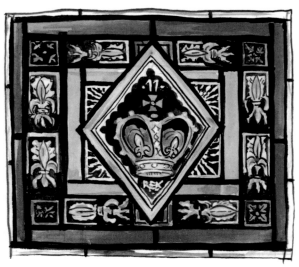

Words by
Angela Ward
2018

Pictures by
Wendy Bramall
2018

Mary's Legacy Continues

Mary was such a wonderful, kind friend to us all. The staff and children of Cheriton Primary School adored her.

During, and after retiring from her Governor post in 2009, each summer Mary would treat the Yr6 children to weaving lessons in her studio. She spent many, many hours preparing for the lessons, sometimes all night – it really was a labour of love!

For the children, this was always the highlight of the term. The fact that she provided juice and biscuits made the visit even more special, she was so generous!

Mary was always keen to share her knowledge and love of weaving with the children. The teachers were all incredibly grateful for her support and expertise. Her cheeky sense of humour will never be forgotten along with the ever-present twinkle in her eye. She once told us that she loved to run around her garden every year on her birthday, just to make sure she could! Such fun, a true adventurer!

Knowing Mary has been a pleasure. She will be remembered fondly and missed hugely by all at Cheriton Primary School.

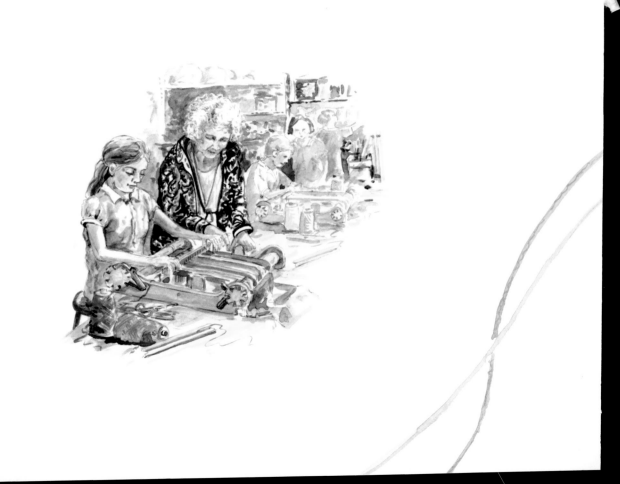